Richard III

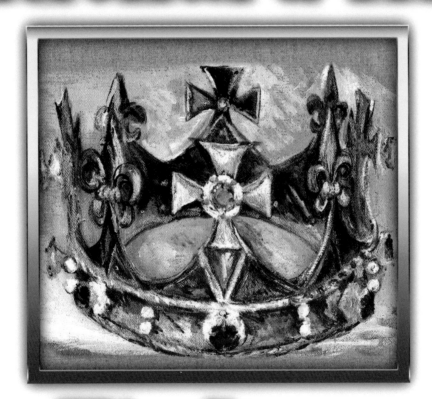

His Story

Kirsteen Thomson

Richard III His Story

MadeGlobal Publishing

For more information on
MadeGlobal Publishing, visit our website:
www.madeglobal.com

Introduction

King Richard III was King for 777 days and was the last King of England to die in battle. He has been described as having a prominent hunched back and being evil, and has even been called the antichrist. Most famously, he was portrayed in an unfavourable light by William Shakespeare.

I became interested in the story of King Richard III not because of who he was, but because of where his body was found. I then started to visit the places that featured in his life. As an artist, when I want to paint a scene, I aim to find out everything I can about the place and the people who have been there, past and present. The creation of this book has led me to read a wide range of books about Richard.

Some historians were certain that Richard III's remains had been thrown into the River Soar in Leicester over 530 years ago and that he was as evil as he had been painted. While the first of these views has been shown to be untrue, the second seems to be a matter of opinion.

Kirsteen Thomson

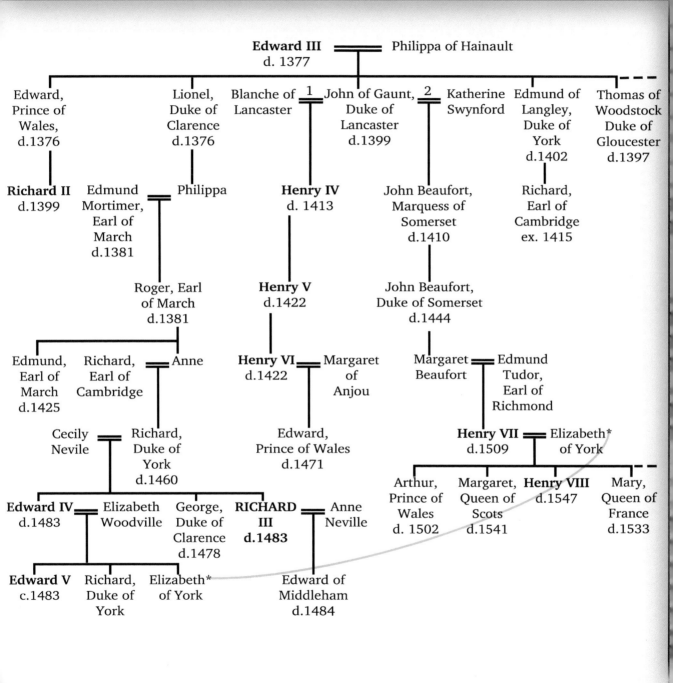

Richard, Duke of York (Richard's Father)

Richard, Duke of York, born on 21 September 1411, was King Richard III's father. In 1415 he inherited the title 'Duke of York' and the estates of his uncle, Edward, Duke of York, following Edward's death at the Battle of Agincourt. Richard, Duke of York, was related to King Edward III through both his father's and mother's sides of the family. He was married to Cecily Neville and was father to twelve children – two of which became Kings of England (Edward IV and Richard III). Richard died on 30 December 1460 at the Battle of Wakefield.

Henry VI

Born in Windsor, on 6 December 1421, the son of Henry V. Upon his father's death, Henry became the youngest ever English king at just 9 months old. Henry's mother, Catherine of Valois, was the daughter of Charles VI of France, so Henry also inherited the throne of France on his grandfather's death. Henry was therefore king of both France and England before the age of one, although he wasn't crowned until November 1429. Henry VI suffered bouts of poor mental health throughout his life and, as a result, Richard, Duke of York, took control of government during critical periods. Following the Battle of Tewkesbury in 1471, Henry VI was imprisoned in the Tower of London and died there on 21 May 1471.

Richard Neville, Earl of Warwick, The Kingmaker

Richard, Earl of Warwick, was born on 22 November 1428 and became one of the richest men in England. He inherited many of his titles and estates through his marriage to Anne Beauchamp, *suo jure* Countess of Warwick. He was cousin to Richard III and was supporter of Richard III's father, Richard, Duke of York. Warwick became a supporter of King Edward IV, but eventually died in battle on 14 April 1471, when he turned against Edward. Warwick was father to Isabel (who married George, Duke of Clarence) and Anne (who married Richard III).

Margaret of Anjou

Margaret was born on 23 March 1430. She came from France in 1445 to marry Henry VI when she was 15 years old, and was crowned queen consort at Westminster Abbey in May 1445. In October 1453, Queen Margaret and Henry VI had their first and only child, Edward, Prince of Wales. During the period when King Henry VI was indisposed due to illness, she oversaw many duties including the raising of taxes. Margaret had Yorkists outlawed in 1459 and refused to recognise Richard, Duke of York, as the heir to the throne, preferring her son, Edward, instead. Margaret became a prisoner of King Edward IV for five years after the Battle of Tewkesbury, until the King of France paid her ransom. At that time, she returned to Anjou where she remained for the rest of her life. Margaret died on 25 August 1482.

William, Lord Hastings

William Hastings, born c.1431, was a descendant of Edward III. Hastings was a close friend of King Edward IV and held the positions of Lord Chamberlain and Master of the Mint. It was Lord Hastings who informed Richard III of his brother, King Edward IV's, death. Hastings was executed for treason on the orders of Richard, who was Duke of Gloucester and Lord Protector at the time, on 13 June 1483.

Sir William Stanley

Born in 1435, Sir William was step-uncle to King Henry VII through his brother, Thomas, Lord Stanley, who was married to King Henry's mother, Margaret Beaufort. It was Sir William Stanley who intervened in the Battle of Bosworth at a critical moment, taking the side of Henry Tudor which paved the way for Henry to claim the crown of England. William Stanley was executed on 16 February 1495, accused of treason and being an accomplice of Perkin Warbeck, a man who claimed to be one of the Princes in the Tower.

Elizabeth Woodville

Born around 1437, Elizabeth's first husband was Sir John Grey of Groby, Leicestershire, a minor-ranked noble who died in the Second Battle of St Albans in February 1461, fighting for the Lancastrian cause. His death left Elizabeth a widow with two sons. How she then came to meet her future husband, King Edward IV, is uncertain — one legend says that she was a sorceress who bewitched him, another legend suggests that she waited for him under an oak tree with her two children to confront him whilst on a hunting trip. Elizabeth became queen consort of England following her secret marriage to Edward on 1 May 1464. Edward and Elizabeth went on to have three sons, including the Princes in the Tower, and seven daughters. Elizabeth died on 8 June 1492 in Bermondsey Abbey.

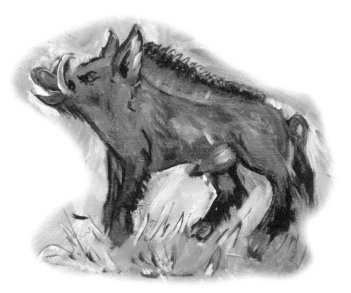

Edward IV

Edward was born on 28 April 1442, the eldest surviving son of Richard, Duke of York. He was the older brother of Richard III. Edward successfully fought against the Lancastrians in numerous battles, including the Battle of Towton in 1461 which led to him becoming King of England from 4 March 1461 until 3 October 1470, and again from 11 April 1471 until his death in 1483. Edward was married to Elizabeth Woodville and they had ten children, including Elizabeth of York (queen consort to Henry VII) and Edward V and Richard of Shrewsbury, the Princes in the Tower. Edward IV died on 9 April 1483. It was after his death that it was alleged that Edward IV had been previously betrothed to Lady Eleanor Talbot, which was considered serious and binding. This possibly made his marriage to Elizabeth Woodville invalid and, therefore, his children from this union illegitimate.

George, Duke of Clarence (brother of Richard III)

George, born in October 1449, became known as George, Duke of Clarence, during his brother, Edward IV's, rule. He married Isabel Neville, daughter of Richard Neville, in July 1469. George was imprisoned in the Tower of London in 1478 and put on trial for treason against Edward IV. He was executed on 18 February 1478. Rumours quickly spread that he had been drowned in a butt of Malmsey wine.

Lady Isabel Neville

Isabel married George, Duke of Clarence, when she was 17 years old. She died two months after the birth of their fourth child, on 22 December 1476. Sadly, the child also died soon afterwards. It was after this that relations between George and his brother, King Edward IV, deteriorated leading to George's execution.

King Richard III

Born on 2 October 1452, Richard was the youngest son of twelve children born to Richard, Duke of York, and Cecily Neville. Richard was made Duke of Gloucester by his brother, King Edward IV. Richard III was husband to Anne Neville and father of their only child, Edward of Middleham. Richard was the last English King to die in battle and his death marked the end of over 300 years of Plantagenet rule. We'll be reading a lot about him in this book...

Henry Stafford, Duke of Buckingham

Born in 1454, Henry had royal blood from both sides and inherited huge wealth. Henry was made a duke in 1465 and went onto marry Catherine Woodville, sister of Elizabeth Woodville, at the age of 12. Henry was Knight of the Garter and acted as High Steward at George, Duke of Clarence's, trial. Henry was Chamberlain at Richard III's coronation and was made Constable of England. He was tried for treason and then executed on 2 November 1483 by King Richard III.

Lady Anne Neville

Anne Neville was born on 11 June 1456 and was the daughter of Richard Neville, Earl of Warwick (known as "Warwick the Kingmaker"), and Anne Beauchamp, 16th Countess of Warwick. Anne's first marriage, to Prince Edward, son of Henry VI and the Lancastrian heir, was arranged by her father. This marriage took place around 13 December 1470.

After the death of her first husband, Anne went on to marry Richard, Duke of Gloucester, some time between June 1472 and January 1473. Richard eventually became King Richard III. As cousins, Richard and Anne were granted a papal dispensation to be legally married. They had one child, Edward of Middleham, Prince of Wales. Anne Neville died on 16 March 1485.

Henry Tudor (King Henry VII)

Henry was born on 28 January 1457 and was the son of Margaret Beaufort and Edmund Tudor (half-brother of Henry VI). He was therefore a distant cousin to Richard III. In 1470, he was given the title Earl of Richmond by Henry VI. Following the death of Henry VI in 1471, Henry Tudor became heir to the Lancastrian claims to the throne and was exiled to France for his own safety. Eventually returning to land in Wales with a small force, Henry defeated Richard III at the Battle of Bosworth in August 1485 and was crowned King Henry VII. Henry married Elizabeth of York to unite the Yorkist and Lancastrian factions, and they had seven children, including Arthur, Prince of Wales, and Henry VIII. Henry VII died on 21 April 1509.

Prince Edward (King Edward V)

Prince Edward, son of Edward IV and Elizabeth Woodville, was born in November 1470. Upon Edward IV's death, young Edward's uncle, Richard, Duke of Gloucester, became Lord Protector to the 12 year-old boy who was now King Edward V. It is not known what happened to Edward and his younger brother, Prince Richard, better known as the Princes in the Tower. The boys were last seen at the Tower of London sometime in August 1483.

Richard of Shrewsbury, Duke of York

Richard was the youngest surviving son of Edward IV and Elizabeth Woodville, and the younger brother of Prince Edward (Edward V). He was born on 17 August 1473. At the age of 4, Prince Richard married the 5 year-old Anne de Mowbray, 8th Duchess of Norfolk. Anne died at the age of 8. Richard was 9 years old when his mother, Elizabeth Woodville, who was in sanctuary in Westminster Abbey, reluctantly agreed for him to join his older brother, Edward, at the Tower of London. The events which led to the disappearance of the Princes in the Tower remain a mystery.

The earliest known surviving portrait of Richard III was painted in 1510 and was copied in 1520 after the original was lost. It showed no sign of the hunched back as portrayed by Shakespeare. Indeed, x-rays of another popular painting – the Windsor Portrait – reveal that it was subsequently painted over to raise one shoulder higher than the other.

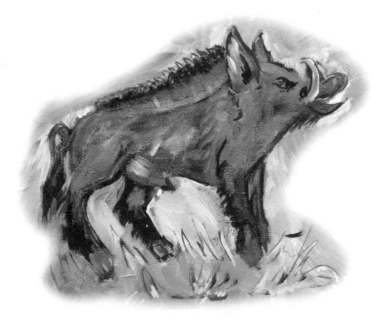

I painted this portrait of Richard III after researching images of him, studying the reconstructed head that is in the Richard III Visitor Centre in Leicester, and using the scientific evidence that was available at the time of King Richard's reburial in March 2015. This portrait is now owned by the Richard III Society.

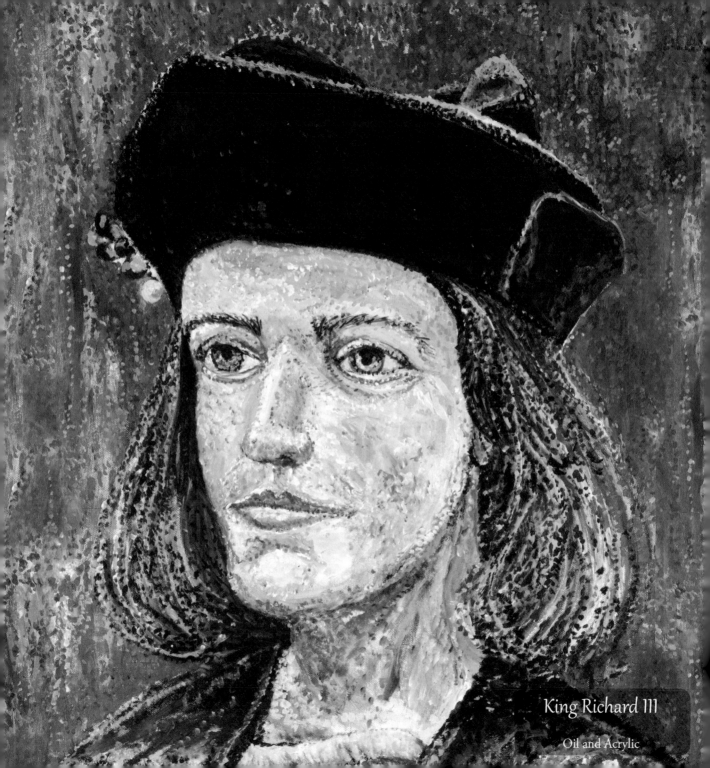

King Richard III

Oil and Acrylic

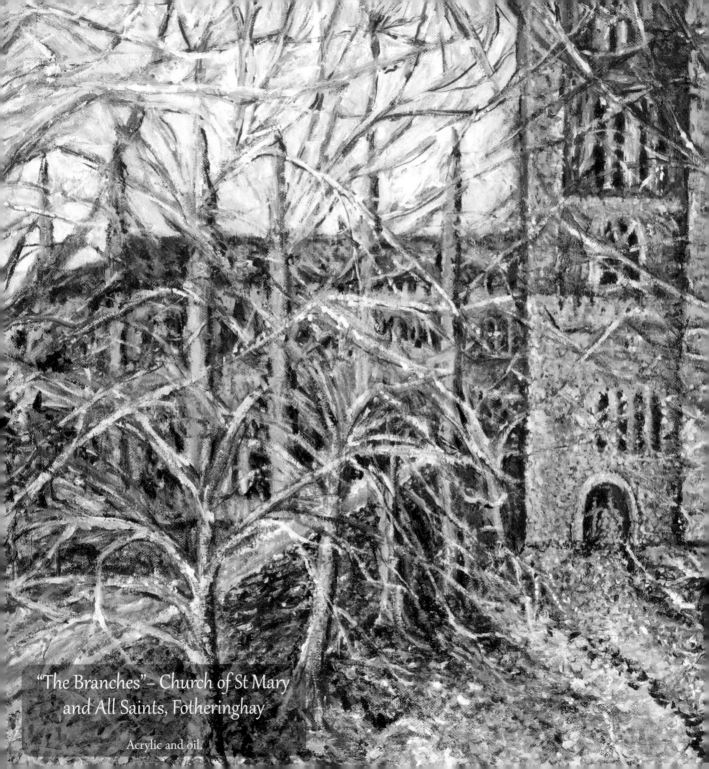

"The Branches"– Church of St Mary
and All Saints, Fotheringhay

Acrylic and oil.

Richard was born on 2 October 1452. He was the youngest surviving child in a family of twelve children. His parents were Richard, Duke of York, who was second in line to England's throne, and Duchess Cecily Neville.

Richard was born at Fotheringhay Castle, Northamptonshire, where a mound and a piece of the castle's stone are all that now remain. Nearby, stands the Church of St Mary and All Saints. In Richard's day, the church would have been twice the size it is today and he might have been christened there, if not at the church within the castle walls.

When Richard was seven, he was moved to the town of Ludlow in Shropshire along with his brother, George, his sister, Margaret, and their mother. At the time, in August 1453, King Henry VI was not fully governing the country because he fell into trance-like states for long periods of time. This lack of strong leadership escalated into civil war between the Yorkists, whose emblem was the White Rose, and the Lancastrians, whose emblem became the Red Rose. This war is now known as the Wars of the Roses.

Richard's father, Richard, Duke of York, felt that he had a strong claim to govern England, and was supported by Richard Neville, Earl of Warwick, a rich and powerful ally. However, Queen Margaret, Henry VI's wife from Anjou, disagreed, believing her son, Edward, Prince of Wales, to be the rightful heir to the throne.

The white rose was not only a symbol for the House of York but has also symbolised purity, being linked to Mary, mother of Jesus. It was also used by the German students who were killed by Hitler in anti-Nazi protests. The white rose is a symbol for Yorkshire, where Richard III spent many happy times. This painting has been mistaken for pastel. I painted it on black card because I wanted it to have a unisex appeal and not be overtly feminine. The acrylic paint was watered down to give it a gentle - but free-flowing - feel, hence the pastel-like appearance. I particularly love the white rose and I used it in my wedding bouquet, so for me it is a bloom that shows honesty, truth and love.

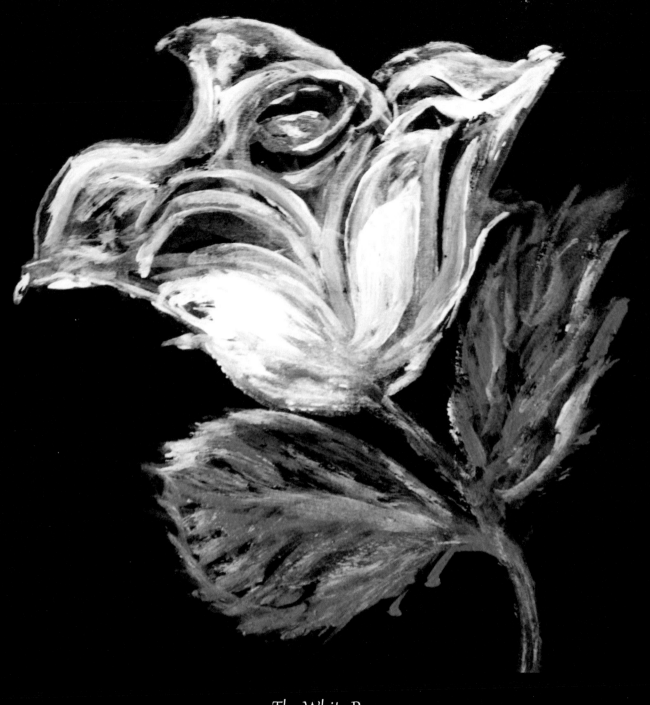

The White Rose

Acrylic

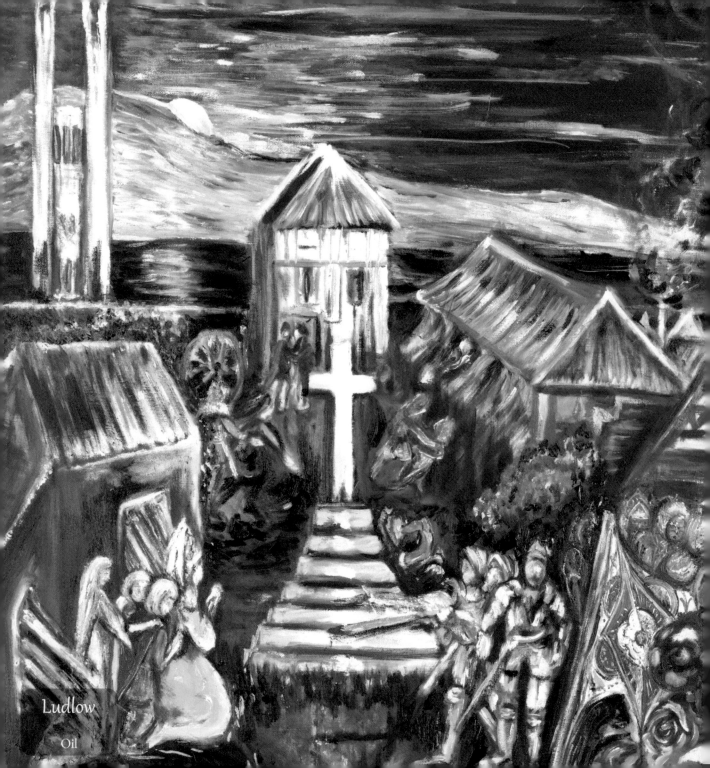

Ludlow

Oil

Growing up in a family who were at the centre of a civil war, Richard witnessed first-hand the sacking of Ludlow in 1459 by the Lancastrian army. It was after this that the young Richard would have learned that his father's army had lost in battle at Ludford Bridge on 12 October that year. The townspeople suffered greatly for supplying the Yorkist army. The victors ran riot after drinking too much, helping themselves to whatever or whomever they wanted. Following this defeat, Richard's father fled to Dublin with his son Edmund. The Earl of Warwick fled to France with Edward, one of Richard's brothers. His mother had no choice but to beg for mercy at the cross in Ludlow's market square. With her remaining children, she was put under house-arrest in the custody of her sister and brother-in-law.

Richard's father and Edmund returned to London in September 1460, where he claimed the throne and it was agreed that he would succeed Henry VI. Queen Margaret was furious that her own son, Edward, had been disinherited and raised an army resulting in the Battle of Wakefield on 30 December 1460. Richard, Duke of York, and Edmund were killed and the Yorkist forces were defeated. Their heads were displayed on pikes over Micklegate, in York. Richard, Duke of York's head was topped with a paper crown in order to mock his ambitions.

This was painted in oil to give the evening deeper, richer tones without being dank and depressing. Richard features along with his brother, George, and his sister, Margaret, who are behind his mother as she begs for mercy from the Lancastrian soldiers. I incorporated the steeple of the church on the left-hand-side, although that would not have been there during the medieval period, because Arthur, first-born child of Henry VII and Elizabeth of York, had his heart buried there.

On 2 February 1461, three suns were apparently seen in the sky at Mortimer's Cross, near Wigmore in Herefordshire, as Edward (future King Edward IV) was preparing for battle against an army led by Henry VI and Margaret of Anjou. The rare phenomenon, now known as a "parhelion" (a reflection of our single sun to look like three), initially frightened Edward's soldiers, but he cleverly turned it to his advantage, claiming that it was a sign sent from God. He persuaded his men that it meant they would be successful in battle, as it represented the "three sons of York" – Edward himself and his two surviving brothers, George and Richard. They indeed won that day's battle, which helped pave the way for Edward to claim the crown of England at the age of eighteen.

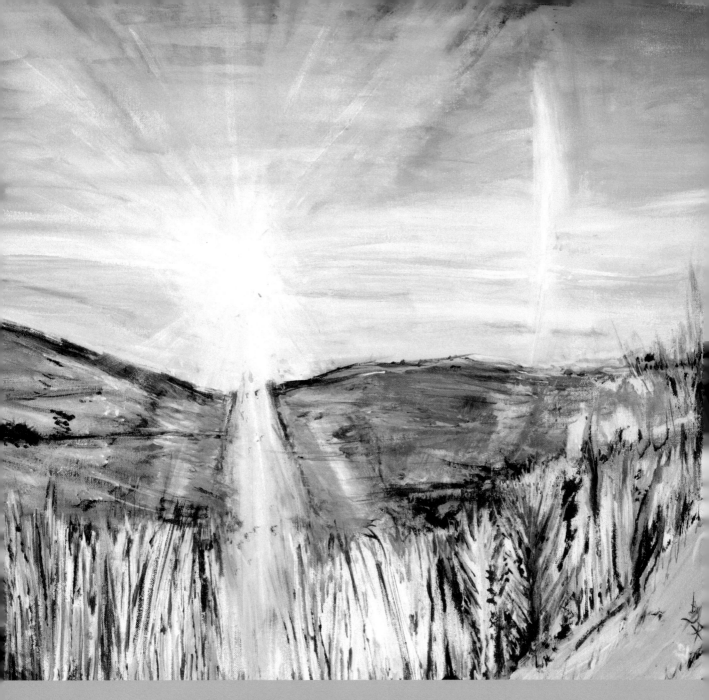

The Three Suns

Acrylic

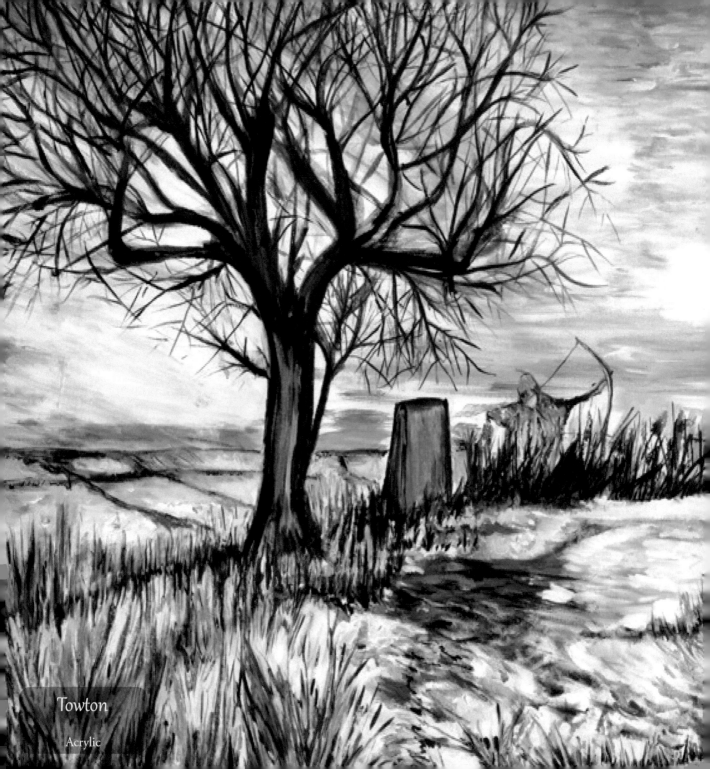

Towton

Acrylic

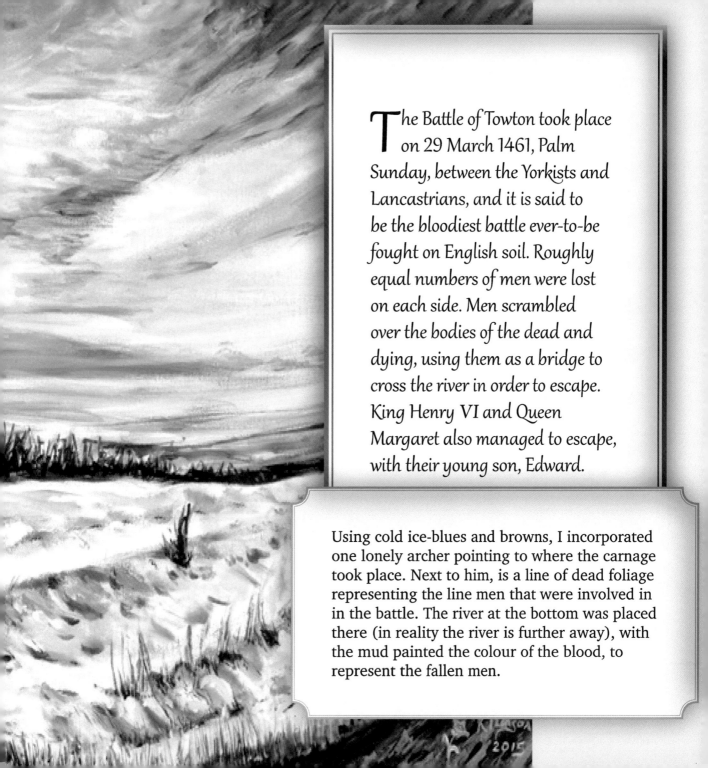

The Battle of Towton took place on 29 March 1461, Palm Sunday, between the Yorkists and Lancastrians, and it is said to be the bloodiest battle ever-to-be fought on English soil. Roughly equal numbers of men were lost on each side. Men scrambled over the bodies of the dead and dying, using them as a bridge to cross the river in order to escape. King Henry VI and Queen Margaret also managed to escape, with their young son, Edward.

Using cold ice-blues and browns, I incorporated one lonely archer pointing to where the carnage took place. Next to him, is a line of dead foliage representing the line men that were involved in in the battle. The river at the bottom was placed there (in reality the river is further away), with the mud painted the colour of the blood, to represent the fallen men.

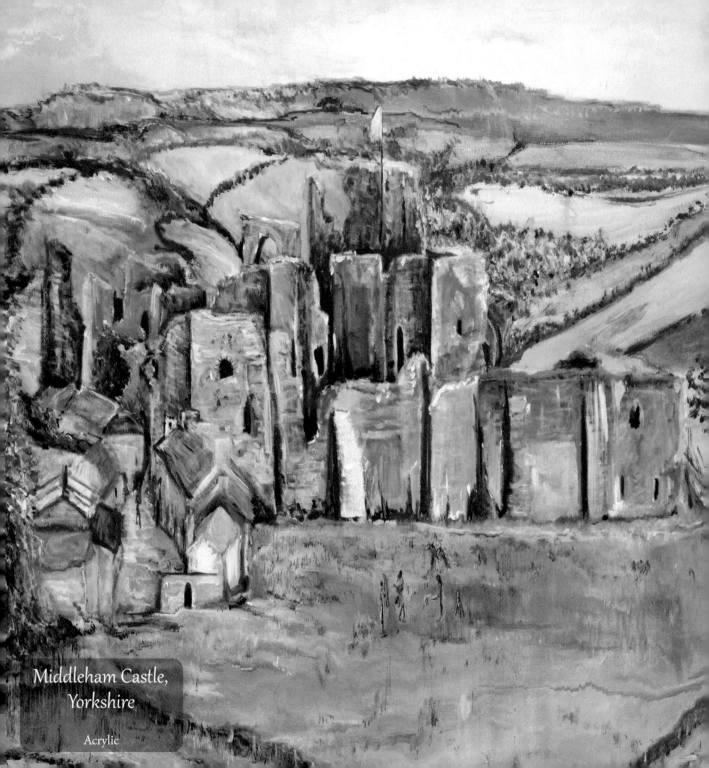

Middleham Castle,
Yorkshire

Acrylic

Following the death of his father, Richard, Duke of York, in 1460, Richard was sent to Middleham Castle, owned by his cousin, the Earl of Warwick, where he was educated. It is likely that it was here that he and his brother, George, met their future wives, Warwick's daughters: Isabel and Anne. Middleham Castle was to become the place where Richard lived with his wife, Anne, and their son Edward.

I painted this picture from the site of the original wooden Middleham Castle, known as Williams Hill, in Yorkshire.
It is roughly 500 yards from the stone Middleham Castle which still stands today.

Sixteen years after the deaths of his father and brother Edmund, Earl of Rutland, Richard led a huge procession of people across the country from Pontefract, in West Yorkshire, leaving on 22 July 1476, to bring their bodies back to his home at Fotheringhay in Northamptonshire. Each night, along the route, the bodies lay on a funeral bier in a church. Four hundred men were paid to follow the procession and others that joined en route were also rewarded. The procession returned on 30 July 1476 and the bodies were buried with honour at the Church of St Mary and All Saints, where King Edward IV met the procession.

This is such an impressive building that I felt it needed a photographic approach to show its beauty. Purple and blue are the dominant colours. Purple signifies the royal connections of Richard's family and the blue tones are colours that Richard was known for. Indeed, blue velvet covered his coffin on its final visit to Bosworth Battlefield Centre during the week leading to his reburial at Leicester Cathedral in 2015. I used yellow in the foreground to bring it towards the viewer, but if you approach the village of Fotheringhay today by road, in the summer, this is the view you will see with the rape seed flowering.

This painting includes a plaque, in front of the tree, that was placed there by the Wakefield Historical Society to commemorate Richard, Duke of York. The figure behind the wall represents Mary, Queen of Scots, who was imprisoned and beheaded on 8 Feb 1587 in Fotheringhay Castle, on the orders of her cousin Elizabeth I.

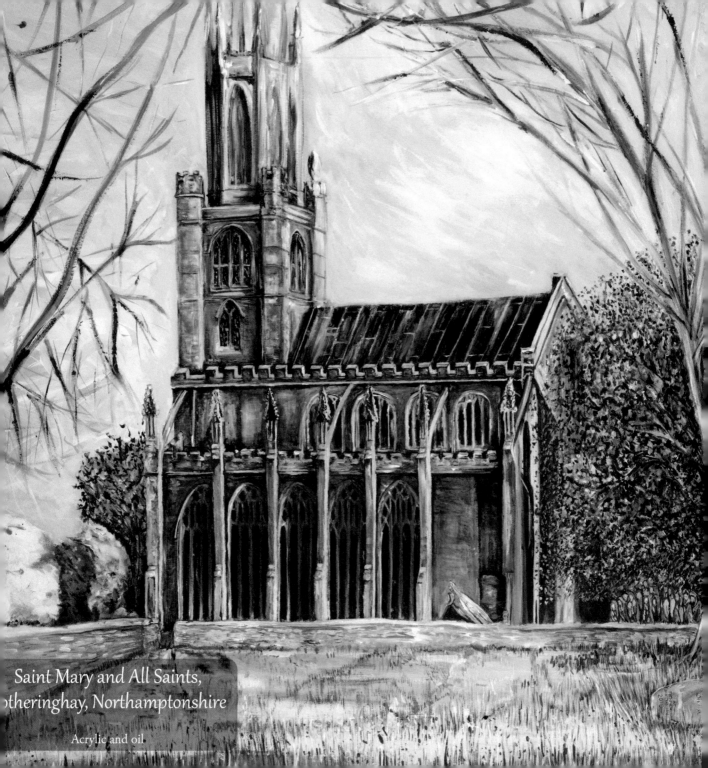

Saint Mary and All Saints,
Fotheringhay, Northamptonshire

Acrylic and oil

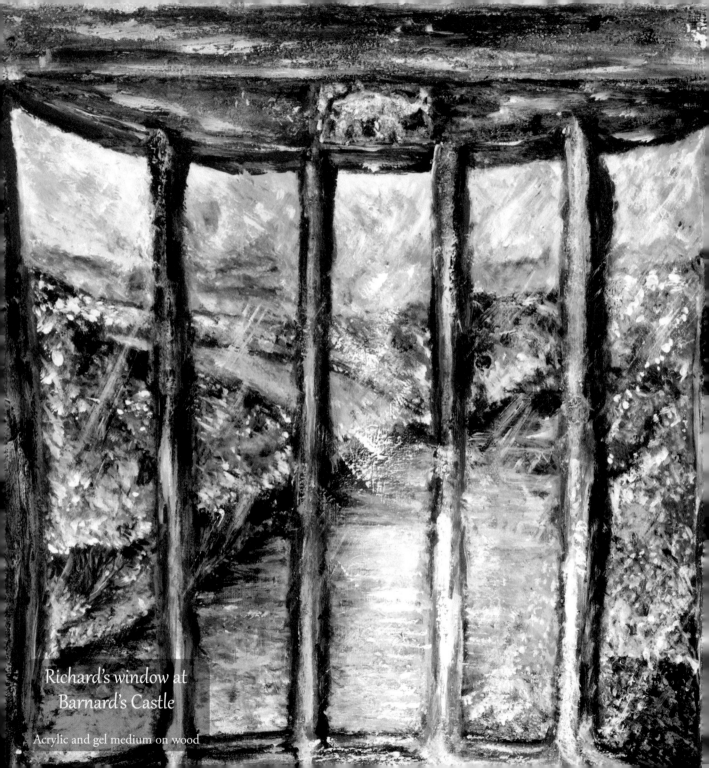

Richard's window at
Barnard's Castle

Acrylic and gel medium on wood

One of the twists in the story is that Richard Neville, Earl of Warwick, eventually turned against Edward IV. This was because he had been undermined when Edward had married Elizabeth Woodville, a widow and minor noble, in a secret ceremony. For diplomatic reasons, Warwick had wanted Edward to marry to create a French alliance. It was after Warwick felt alienated from King Edward's court, and the Woodville family's influence and power had grown, that Warwick turned against Edward. In an act of defiance, he married his eldest daughter, Isabel, to King Edward's brother, George, Duke of Clarence, and later married his youngest daughter, Anne, to Henry VI's son, who was a Lancastrian.

This curved window was installed in Barnard's Castle by Richard III and can be seen today with his emblem, the Boar, above it. Richard was known as the Lord of the North, keeping order in this region for King Edward IV. He successfully fought for him in the Battles of Barnet and Tewkesbury in 1471. I painted this in gel medium to symbolise the roughness of the stone and the wildness of the beautiful surrounding area. It was blowing a gale and I was nearly blown off my feet several times. The fact I was painting on heavier wood was helpful that day. As I was painting, a double rainbow appeared, the sun broke through and it seemed that I was in a place that would help centre the mind.

A boar was the personal emblem of King Richard III, and silver boar badges were worn by high-ranking nobles. A silver boar badge and some battered lead balls, proving that there was artillery used on both sides, were found in 2010 at the Bosworth battlefield site, near where Richard III was killed in battle. This helped to pin-point the site of the battle.

The Richard III Society was originally known as 'The Fellowship of the White Boar' when it was founded in 1924. The Society's aims were to promote historical research into the life of King Richard III. Saxon Barton, founder of the Richard III Society, explained: 'in my view, historical belief must be founded on facts where possible, and on honest conviction'.

The White Boar

Acrylic

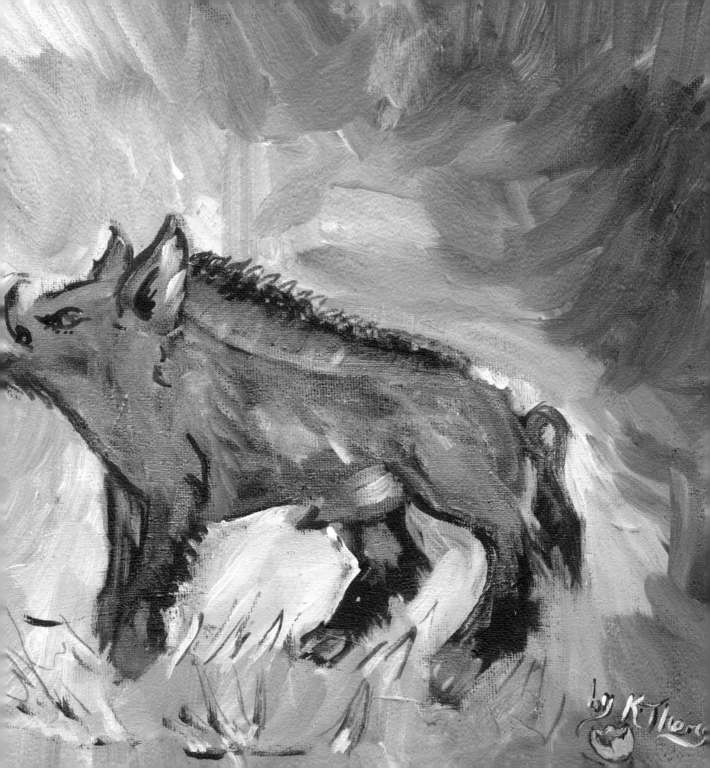

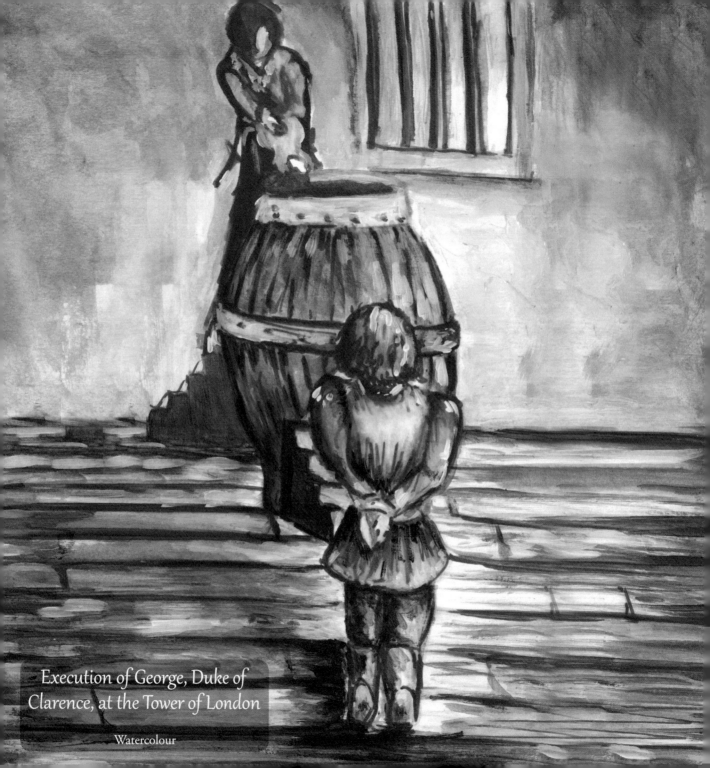

Execution of George, Duke of Clarence, at the Tower of London

Watercolour

Just before the death of Richard Neville, Earl of Warwick', George, Duke of Clarence, decided to re-join his brother, King Edward IV. King Edward forgave him for joining forces with Warwick and marrying Warwick's daughter, Isabel, without his permission. Isabel died two months after giving birth to a son on 22 December 1476 and the baby sadly died soon after. This sent George into a frenzy of recriminations. Firstly, he turned against Isabel's ladies-in-waiting, including Ankarette Twynyho, who George accused of poisoning his wife. Ankarette was put on trial, found guilty and hanged until she was dead. The jury claimed that George had threatened them, forcing them to reach a guilty verdict against Isabel's lady-in-waiting.

George then accused King Edward's wife of witchcraft. As a result, he was found guilty of treason and Edward IV passed a death sentence on his own brother. It is rumoured that the only choice George was given was how he would die and that he chose to be drowned in a butt (105 gallons) of Malmsey wine, dying on 18 February 1478.

*I*n 1482, King Edward IV gave his brother, Richard (by then, the Duke of Gloucester), command of 20,000 men and instructed him to go to Scotland to win the Scottish throne from King James III. Richard was accompanied by the half-brother of the Scottish King – the Duke of Albany.

If Richard was victorious, it was agreed that the Duke of Albany would become ruler of Scotland and that he would allow England to control external affairs. Richard and Albany took control of the border town of Berwick-Upon-Tweed and continued on to Edinburgh. However, they were unable to get into Edinburgh Castle. Richard forbade his army from taking the spoils of war that his troops expected. Instead, by demonstrating his authority, he controlled his men and a truce was agreed.

This was painted in oil to give the colours an added intensity. The light is slightly whiter in hue in Scotland. I have depicted a stormy sky, reflecting the mood of a castle under siege. At the left of the image is a figure on horseback looking up, I imagine this could well be Richard. Under the trees, are other shadowy figures which could either be Richard's men or a mix of people throughout time that have enjoyed looking up at the castle and the gardens that are there today. A Scottish flag was inserted to show their triumph over the English.

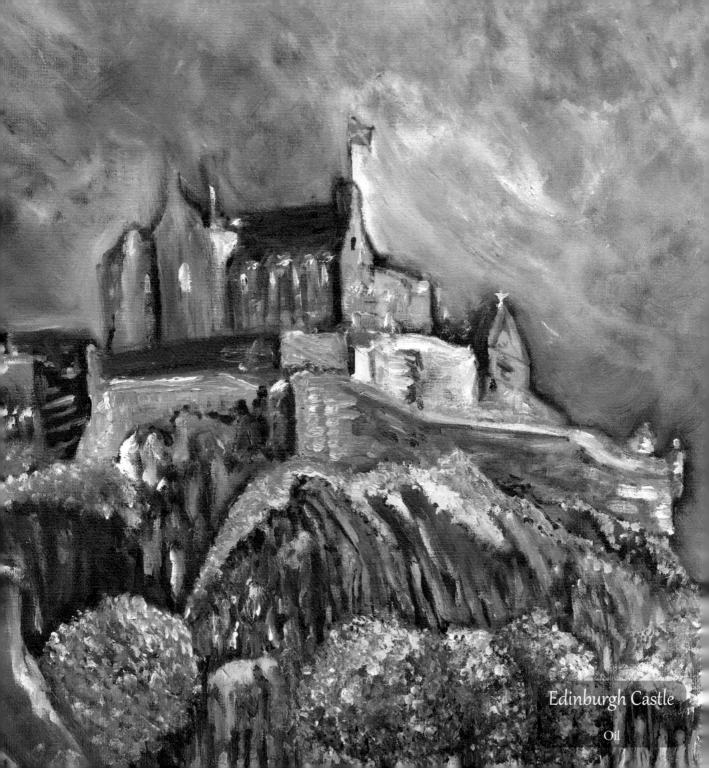

Edinburgh Castle

Oil

In 1483, while Richard, Duke of Gloucester, was still in the north of England, he received a letter from his brother's closest friend, William, Lord Hastings, informing him of the sudden death of King Edward IV and urging him to return to London. Historians agree that, up to this point, Richard was loyal to his brother and was known as a brave knight. On hearing the news of King Edward's death, Richard rode to York to get the Lords to swear loyalty to his twelve-year-old nephew, Prince Edward. Before King Edward IV died, he had left instructions naming Richard as Lord Protector until his son was old enough to rule. Enroute to London, Richard met up with Henry Stafford, Duke of Buckingham, and they intercepted the young Prince Edward's party, which was travelling from Ludlow to London for Edward's coronation. It is here that this story takes a controversial turn. Richard rode on to London with his young nephew. Young Edward was put into the Tower of London, which was not only a prison but also a palace. It was traditional for monarchs to stay there before being crowned. Prince Edward's younger brother, Richard of Shrewsbury, Duke of York, later joined him in the Tower.

Two months later, Richard was called out of what had been an agreeable council meeting in the Tower. He returned angry, with soldiers, accompanied by the shout of 'Treason!' Lord Hastings was promptly taken out of the White Tower and beheaded on a tree stump. He is thought to have died on Friday 13 June 1483. It was around this time that work ceased on the building of Kirby Muxloe Castle, which had been commissioned by Hastings himself.

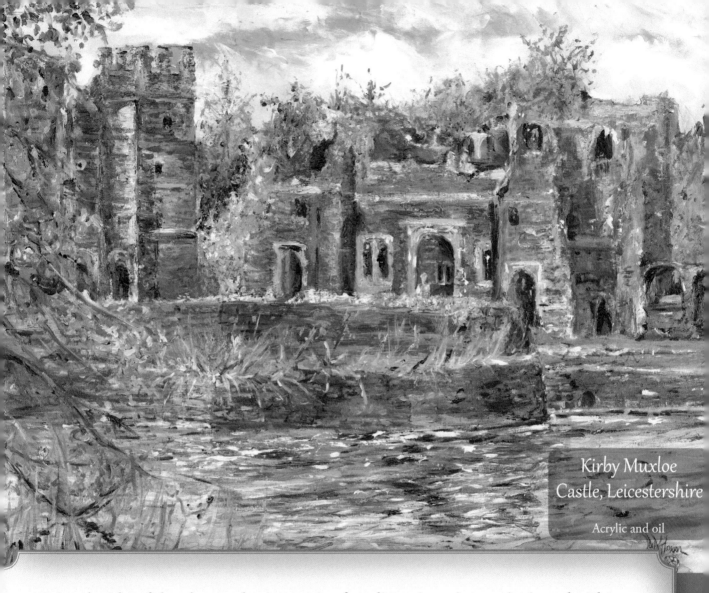

Kirby Muxloe
Castle, Leicestershire

Acrylic and oil

Painted with soft brushes, and using a mix of mediums in an impressionist style, I have tried to show how much this building is loved locally by the people who walk and fish there today. Much attention to detail can be seen in the brickwork, reflecting the Flemish style of the builders who came from overseas and supposedly returned there after finding out about the death of their employer, William, Lord Hastings. Since completing this painting, I have discovered that the original drawbridge is housed in a barn a few metres behind my house! It is a small world.

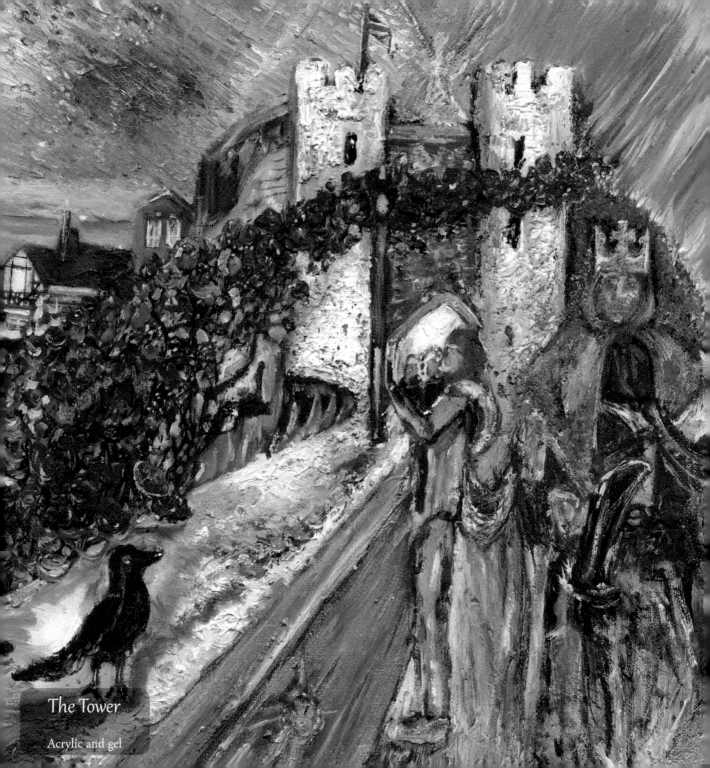

The Tower

Acrylic and gel

Around this time, it was revealed by Robert Stillington, Bishop of Bath and Wells, that the now-deceased King Edward IV had been married before he married Elizabeth Woodville. This announcement rendered Edward's children, the Princes in the Tower, illegitimate and unable to inherit the throne.

On 25 June 1483, Parliament declared the two Princes illegitimate. As a result, the Lords asked Richard to accept the throne. Richard was crowned king in a double coronation with his wife, Anne, on 6 July 1483 at Westminster Abbey.

An attempt to either free or capture the Princes was thwarted in 1483. The Princes were last seen playing outside in the gardens of the Tower and what happened to them has remained a mystery ever since.

A gel medium was used to give the Tower a serious, gritty, inescapable quality. Varnish and gel were used to give a shinier tone on the poppies of remembrance. The last ceramic poppy of remembrance for those killed during World War One was laid at the Tower on 11 November 2014, raising money for charity. The black raven is one of the ravens that have lived in the Tower for centuries. There is a superstition that when the last raven leaves the Tower of London that the crown will fall and so will the kingdom. Even though the poppies were not related to the struggles and battles of Richard III, I felt that they were an apt way to capture this part of his story.

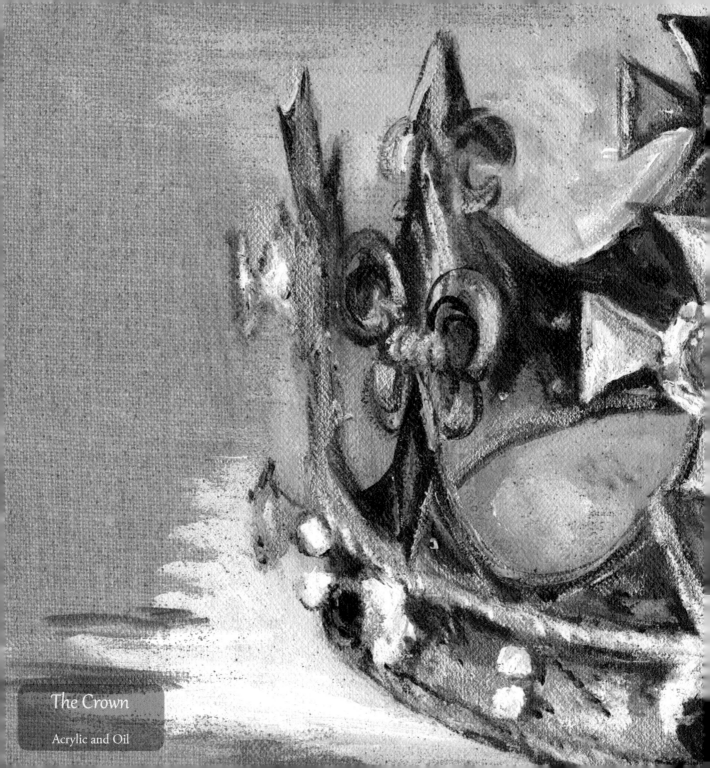

The Crown

Acrylic and Oil

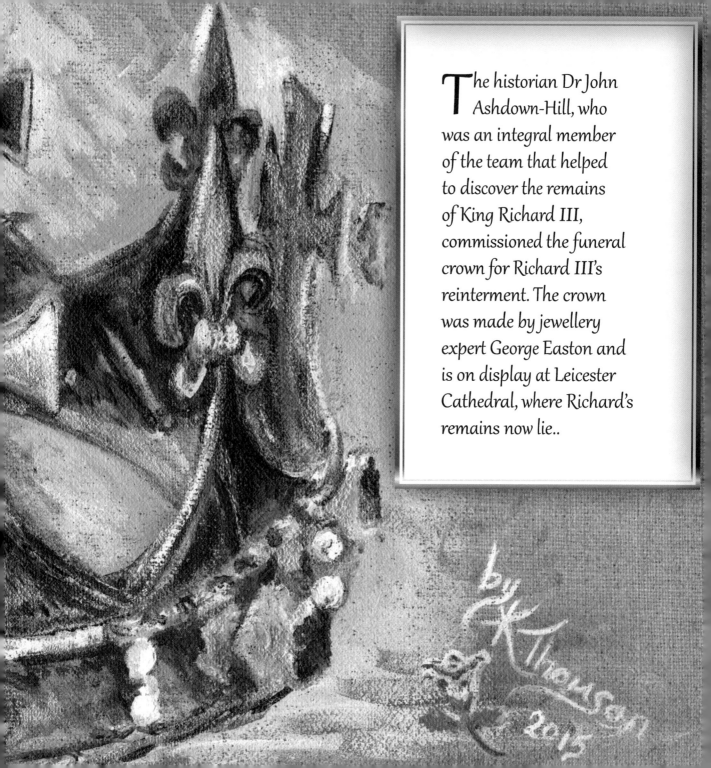

The historian Dr John Ashdown-Hill, who was an integral member of the team that helped to discover the remains of King Richard III, commissioned the funeral crown for Richard III's reinterment. The crown was made by jewellery expert George Easton and is on display at Leicester Cathedral, where Richard's remains now lie..

by K Thomson 2015

R ichard and his wife, Anne, were so fond of Nottingham Castle that they called it their 'castle of care'. Interestingly, the caves under Nottingham Castle, which can still be visited today, were man-made and date back to medieval times. Richard III is said to have overseen the construction of one of these tunnels.

On 11 August 1485, news of Henry Tudor's landing in Wales first reached Richard, while he was at Nottingham Castle. Upon hearing the news of Henry Tudor's invasion, whilst out hunting, Richard had to act decisively as to how to counter the threat to his rule. Accompanied by his forces, he left Nottingham Castle to travel to Leicester, where he stayed overnight.

My painting was inspired by the occasion at Nottingham Castle when Richard and Anne received the dreadful news that their only son, Edward, had died at the age of ten in 1484. They were said to have been nearly mad with grief and only months later Anne herself became ill, dying on 16 March 1485.

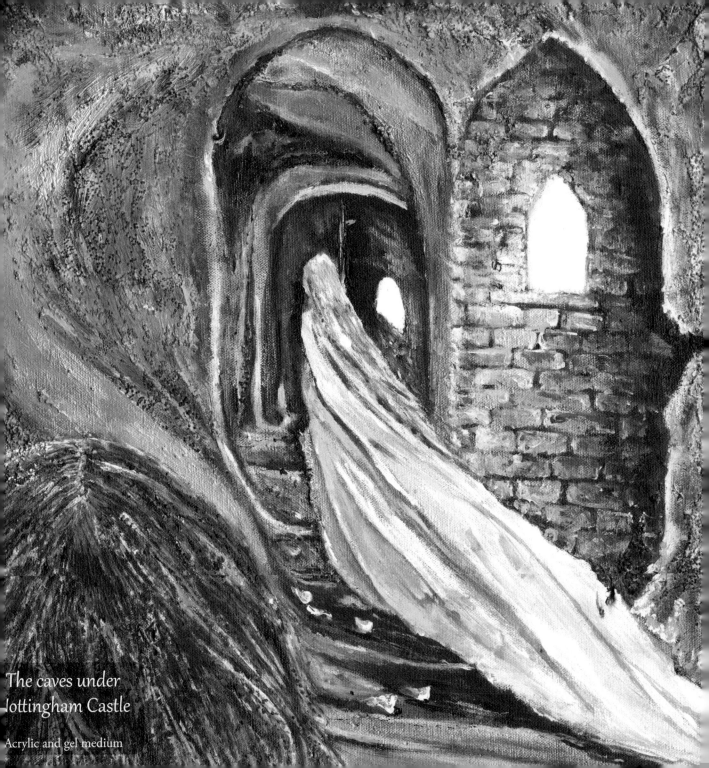

The caves under
Nottingham Castle

Acrylic and gel medium

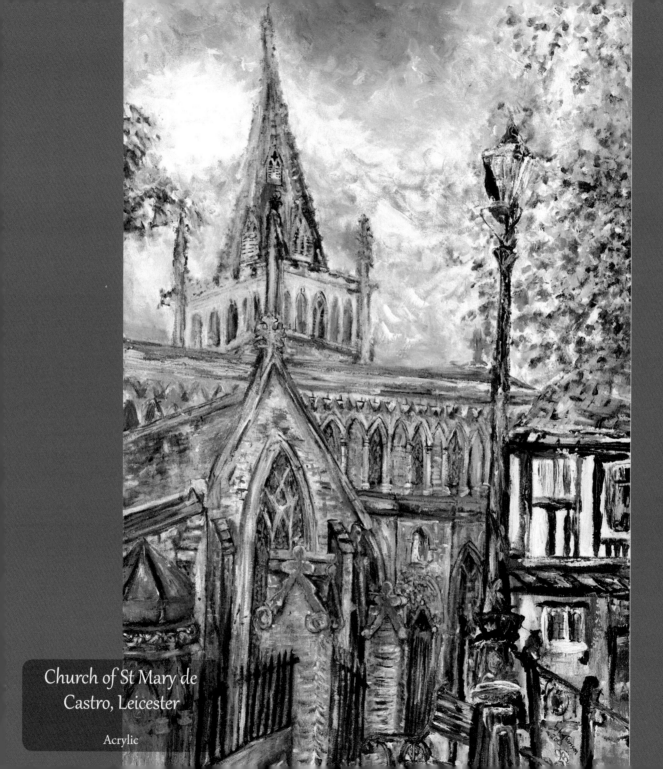

Church of St Mary de
Castro, Leicester

Acrylic

Richard III left Leicester heading towards Market Bosworth. Henry Tudor had landed in Milford Haven, in Wales, on 7 August 1485. With him, Henry brought men from France, many of whom were prisoners who were let out of jail to fight for him.

As Henry Tudor travelled towards Leicester, more troops joined him. Henry hoped for more men from his step-father, Lord Thomas Stanley, but Richard III also hoped for support from Lord Stanley's men. To guarantee support from Lord Thomas Stanley and his brother, Sir William Stanley, Richard III took Lord Strange, Lord Stanley's son with him. The two armies prepared for battle in fields near the small town of Market Bosworth. The army of Henry Tudor was outnumbered three-to-one by King Richard's army.

This is the church next to Leicester Castle, where Richard III is reputed to have stayed in the past. In August 1485, Richard is thought to have stayed at the White Boar Inn (which is now a Travellodge in Leicester!) and which is only a few minutes' walk from Leicester Castle. The castle was in disrepair and thought not good enough for a King to stay in. Richard lit a candle in St Mary de Castro in memory of his father, Richard, Duke of York. Both his father and Henry VI had been knighted there in 1426. Henry VI and Richard, Duke of York, were both descendants of Edward III and, as such, distant cousins.

King Richard III was a religious man. It is rumoured that he stopped at the Church of St James to pray the night before his final battle, known today as the Battle of Bosworth, against Henry Tudor. In all probability, it was on the route from Leicester to the battlefield and it was a hot and dusty August day. A cool church would have provided some welcome relief. After praying, Richard went on and made camp for what was to be his last night.

I knelt and imagined where someone might kneel and pray for their life. The next day, I returned to finish my painting and decided to visit the Bosworth Battlefield Centre, which was not far away. It was then that I met historians Philippa Langley and Michael Jones when they launched their book. I asked Michael and Philippa if the rumour could possibly be true? Did King Richard III pass behind my garden gate, which was the Old London and Roman road, on his way to The Battle of Bosworth? After discussing the position of my house, they said that they thought it was highly likely. It was then that I decided to paint places of meaning in the story of King Richard III. This was painted on 2 October 2013, the anniversary of Richard III's birthday.

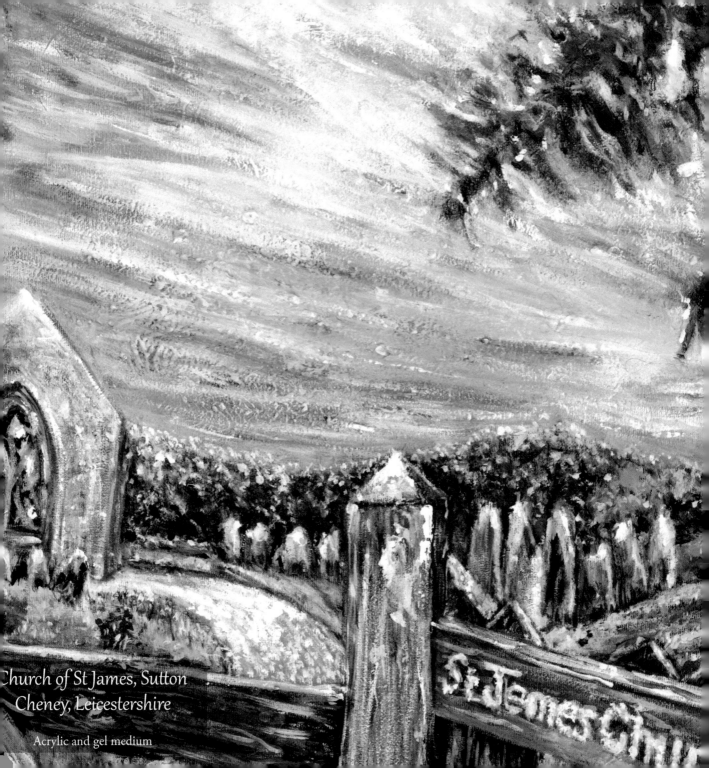

Church of St James, Sutton
Cheney, Leicestershire

Acrylic and gel medium

St James Chu

It seems that, despite his prayers, King Richard III was not granted one last, peaceful night's sleep. It is reported that he tossed and turned, plagued by bad dreams in his tent. Yet the fateful morning came soon enough. Lord Thomas Stanley sent word that he was ill and did not appear.

On the morning of 22 August 1485, Richard III's men were waiting when Henry's men trampled through fields from the area of Merevale Abbey into their position. By mid-morning they were ready to start battle.

During the battle, Henry Tudor moved into an exposed position. Before leading a charge, Richard III put on a loose fitting robe over his armour, displaying the royal coat of arms. Seeing this, Henry Tudor dismounted and was surrounded by his personal bodyguards, who raised large pikes to protect him. Richard III advanced towards Henry and cut down Henry's standard bearer, William Brandon. King Richard got so close to Henry Tudor that, even at just five feet seven inches in height, he was able to cut down Henry's huge bodyguard, Sir John Cheney, who stood a whole foot taller.

However, disaster struck when a shoe from Richard's horse came off in the boggy marsh and he was thrown to the ground. It was at this point that Sir William Stanley, who had been waiting with his own forces nearby to see which way the battle turned, decided to make his move. Sir William Stanley ordered his men to support Henry Tudor, a move that finally decided the battle's outcome. In the midst of battle, King Richard was offered a horse on which to escape by his men, but he refused – even his enemies said Richard III fought bravely to the end. Richard was not able to reach Henry Tudor. In the meleé, Richard's helmet was cut off, leaving marks on his chin. His head was now vulnerable to attack and eventually the King was brought to his knees. A final death blow sliced through his skull.

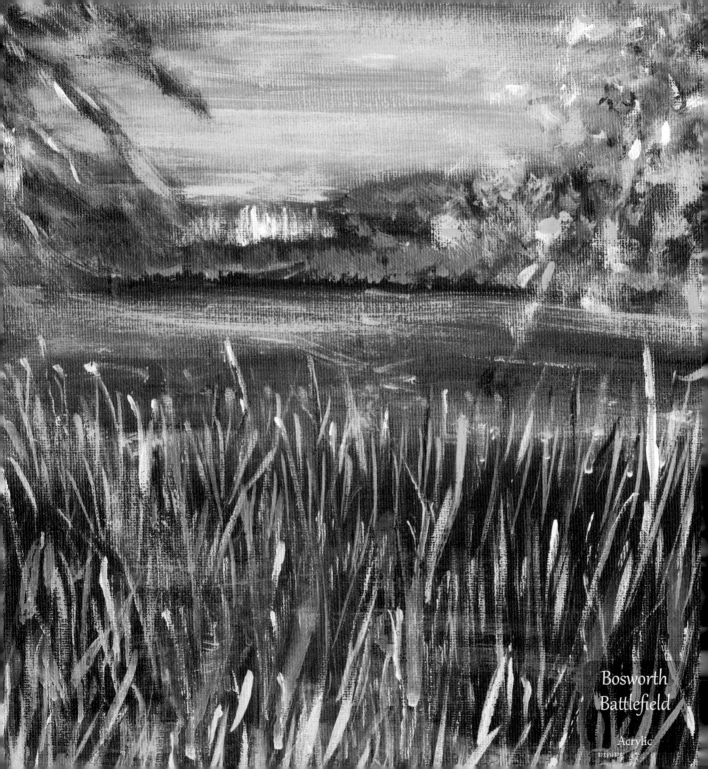

Bosworth
Battlefield

Acrylic

The battle was soon over once Richard had been killed.

The crown that Richard III had been wearing was found in some bushes and was immediately taken to Henry Tudor, whose rural coronation took place either in, or nearby, the Church of St Margaret of Antioch, at the nearby village of Stoke Golding. Sword marks can be seen at the church where Henry Tudor's soldiers sharpened their swords before the battle. This is the birthplace of the Tudor dynasty.

The path leading to the doors of the church symbolises the path of life that Henry had chosen to take in his journey towards the crown, the life he and his mother Margaret Beaufort had both longingly worked towards. In my painting, I imagined Henry Tudor's shadow on this path where he may have started to make his way into the church to be crowned. The shadow of the crown is on the path, for even if he was not already wearing it he could have imagined how it felt. Ruby red is depicted on the path, showing the way to the door as if it is a line of blood. Also, Henry would have worn a red gown during his coronation in London. Green was used to represent the Tudor house, which is heavily painted on the surrounding shrubbery, along with the Lancastrian red roses.

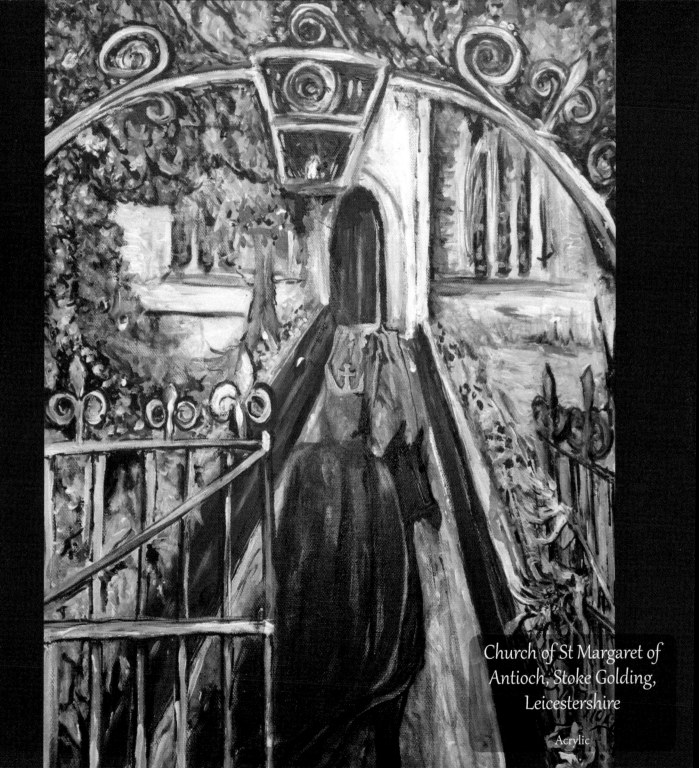

Church of St Margaret of
Antioch, Stoke Golding,
Leicestershire

Acrylic

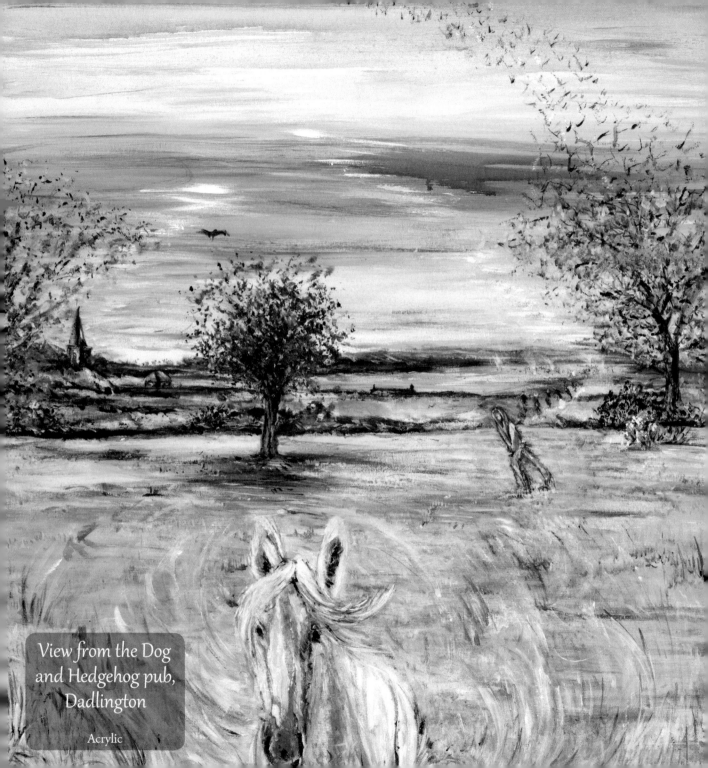

View from the Dog
and Hedgehog pub,
Dadlington

Acrylic

Richard III's body was stripped, tied and thrown over a horse. His body was abused, with the exception of his face, and taken back to Leicester, where it was displayed for a few days so that people could see that the king really was dead. Richard's remains were buried in the Church of Greyfriars on 25 August 1485. Richard III had been the last Plantagenet king and the last English king to die in battle

The spire of the Church of St Margaret of Antioch is on the far left of the picture. The area where the Battle of Bosworth took place is to the right. The line of people walking shows the path to where the men who died in the battle were taken to be buried. This was at the church in Dadlington, which would be behind the viewer – a plaque now marks the place where they were laid to rest.

An archaeological dig, led by Philippa Langley, was started on 25 August 2012 in a social services' car park in Leicester, with the goal of finding Richard III's body. Philippa was helped by leading historian John Ashdown-Hill, who had determined the dig to be the location of the former Greyfriars Church. It was by no means certain that King Richard III would be found. Many believed that Richard's remains had been thrown into the River Soar during the dissolution of the monasteries in the reign of Henry VIII, and the river had been dredged many times since then. The many years of work to get permission and funding for the dig were rewarded when the mortal remains of King Richard III were discovered on the first day of the dig, ironically under the letter 'R' marked on the tarmac. It was the same date, 25 August, that he appeared to be rather hurriedly buried in a cavity that was too short for him. Many questions about King Richard III's life have now been answered by Leicester University through research and DNA. It is now proven that Richard III had scoliosis that would have developed in adolescence, giving him a slightly curved spine but not the exaggerated higher shoulder or hunched back that had been repainted over a contemporary portrait of Richard. There was no withered arm, as had been portrayed in the play by Shakespeare. His hair was not black but had been blond in childhood, probably darkening as he got older, and he had blue eyes.

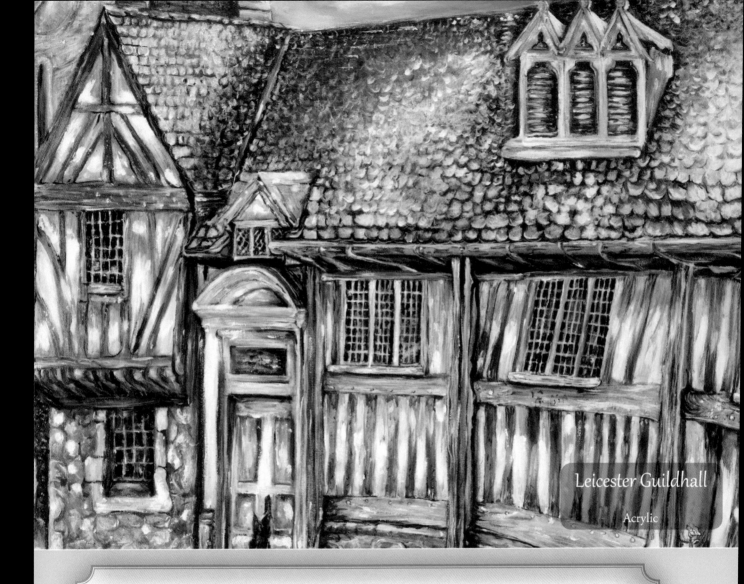

Leicester Guildhall

Acrylic

The Guildhall is one of the oldest buildings in Leicester. In the past, it has served as a court house, and the jails can still be seen today. It is likely that Richard passed by this building and it was here that it was confirmed by Leicester University, at a press conference in February 2013, that the remains found in a social services' car park were those of King Richard III of England.

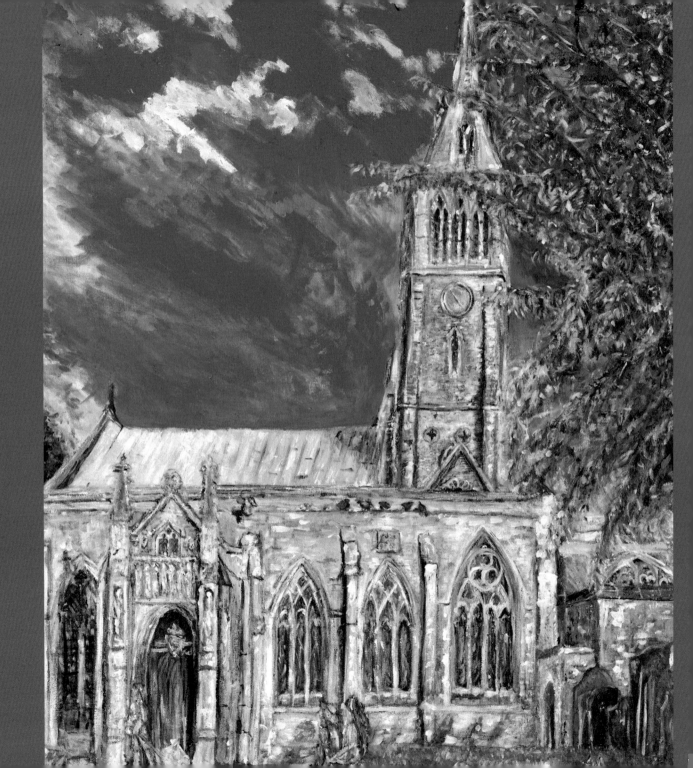

The re-burial of Richard III was in sharp contrast to his first. His remains were encased with care in a coffin made from oak from the estate of Prince Charles and made with the skilled hands of his descendant, Michael Ibsen. On Sunday 22 March 2015, King Richard III was taken with dignity and honour from Leicester University to Bosworth Battlefield, where a service was held. People then lined the route from Bosworth Battlefield Centre to the city of Leicester itself. The city streets were crowded and many people threw white roses onto Richard's coffin. In the following days, his coffin was laid in state and people queued for hours in order to file past him in the cathedral.

Richard was finally reburied in Leicester Cathedral on 26 March 2015, in a position which is virtually opposite the car park in which his remains, buried 530 years earlier, had been re-discovered. During the dissolution of the monasteries in King Henry VIII's rule, Greyfriars Church was dismantled and some of its timber was used to mend parts of the roof in the Cathedral Church of St Martin, now more widely known as Leicester Cathedral. Since King Richard III was laid to rest under these timbers, it could be said he is now under the same roof that covered him when he was originally laid to rest.

I painted this before Leicester Cathedral's new gardens were opened in July 2014. The wall of the old gardens and the position of some of the tombstones highlight this. I painted this large canvas by propping it on one of the walls that are no longer there, thankfully sparing me from having to carry a large and heavy easel. The sky was this stunning blue colour in September 2012. I painted vague figures in brown leaving their identity and the date they lived in unknown. I thought of them as representations of different people from different times that have used Leicester Cathedral.

Kirsteen Thomson is a British artist, framer and photographer. Currently based in Leicester, but originally from Scotland, she trained in Art and Design at De Montfort University before embarking on a career as a diplomat for the Foreign and Commonwealth Office. Kirsteen works with a mixed medium of watercolour, acrylics, gel mediums and oils.

MadeGlobal Publishing

Non Fiction History

Illustrated Kings and Queens of England
- **Claire Ridgway**
Anne Boleyn's Letter from the Tower - **Sandra Vasoli**
Jasper Tudor - **Debra Bayani**
Tudor Places of Great Britain - **Claire Ridgway**
A History of the English Monarchy - **Gareth Russell**
The Fall of Anne Boleyn - **Claire Ridgway**
George Boleyn: Tudor Poet, Courtier & Diplomat
- **Ridgway & Cherry**
The Anne Boleyn Collection - **Claire Ridgway**
The Anne Boleyn Collection II - **Claire Ridgway**
Two Gentleman Poets at the Court of Henry VIII
- **Edmond Bapst**
A Mountain Road - **Douglas Weddell Thompson**

Children's Books

All about Richard III - **Amy Licence**
All about Henry VII - **Amy Licence**
All about Henry VIII - **Amy Licence**
Tudor Tales William at Hampton Court - **Alan Wybrow**

"History in a Nutshell Series"

Sweating Sickness in a Nutshell - **Claire Ridgway**
Mary Boleyn in a Nutshell - **Sarah Bryson**
Thomas Cranmer in a Nutshell - **Beth von Staats**
Henry VIII's Health in a Nutshell - **Kyra Kramer**
Catherine Carey in a Nutshell - **Adrienne Dillard**

Historical Fiction

The Colour of Poison - **Toni Mount**
Between Two Kings - **Olivia Longueville**
Phoenix Rising - **Hunter S. Jones**
Cor Rotto - **Adrienne Dillard**
The Claimant - **Simon Anderson**
The Truth of the Line - **Melanie V. Taylor**
Struck by the Dart of Love - **Sandra Vasoli**
Truth Endures - **Sandra Vasoli**

Please Leave a Review

If you enjoyed this book, *please* leave a review at the book seller where you purchased it. There is no better way to thank the author and it really does make a huge difference! *Thank you in advance.*